JUL 2 6 2018

D0626987

Auguste Rodin (1840–1917) is a colossus in the history of art. In a career that spanned the late nineteenth and early twentieth centuries, the Paris-born sculptor rebelled against the idealized forms and practices of traditional art and paved the way for the birth of modern sculpture. While he believed that art should be true to nature, he sought to penetrate beneath the surface appearance and to express inner truths of the human psyche. The hallmarks of his style – its highly eroticized, sometimes explicit character, his use of incomplete figures, his emphasis on formal qualities rather than on narrative, and his desire to retain the marks of the sculptural process – were considered revolutionary at the time. As a result, his intense, evocative works courted controversy, inspiring violent hatred and ardent admiration in equal measure.

By the end of his life, however, his reputation was established and he had become one of the most celebrated artists in the world. This centenary facsimile edition faithfully reproduces the pages of a 1918 volume published immediately in the wake of Rodin's death. With an essay by American artist, critic, and teacher Louis Weinberg, it presents almost seventy of Rodin's greatest works in a beautiful clothbound format for a contemporary audience.

THE MODERN LIBRARY
OF THE WORLD'S BEST BOOKS

THE ART OF RODIN

WITHDRAWN

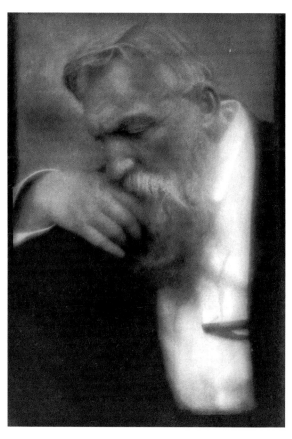

PORTRAIT OF RODIN
By Steichen

THE ART OF RODIN

Introduction by LOUIS WEINBERG

THE MODERN LIBRARY

PUBLISHERS : NEW YORK

COPYRIGHT, 1918, BY

BONI & LIVERIGHT, Inc.

MANUFACTURED IN THE UNITED STATES OF AMERICA
FOR THE MODERN LIBRARY, INC., BY H. WOLFF

CONTENTS

LIST OF ILLUSTRATIONS

9

ILLUSTRATIONS

ILLUSTRATIONS

12

THE ART OF RODIN

AN ESSAY BY

LOUIS WEINBERG

AUGUSTE RODIN

In the year 1877 Auguste Rodin, then thirty-seven years of age, exhibited at the Salon in Paris for the first time. Eleven years earlier he had submitted the head of "The Man With a Broken Nose," but that had been rejected. At last, after having studied since he was a boy and having earned his living at sculpture as an anonymous assistant to others, he appeared before the critics and public of Paris, his native city, with the full-length figure of "The Man of the Age of Bronze."

Up to this time there had been nothing eventful. Of his parents little has been written except that his father, a Norman, was a clerk in the Central Police Office in Paris, and that his mother, of Lorraine origin, helped through her sacrifices to enable him to attend boarding school as a child. At fourteen he was sent for drawing lessons to a school in the Latin quarter, where he discovered his calling in the modelling class. From that day, it was a story of almost unintermittent work. During the three years spent at the school he also drew from the antique at the Louvre, studied and copied prints in the Imperial Library, and practised memory drawing at home in the evenings. Then followed a course of lessons under Barye, the famous animal sculptor, after which he applied to the Ecole des Beaux Arts, which three times in succession refused to enter him upon its rolls.

After that all formal study in school and under-

masters ceased. Rodin became a workman, but more than ever a student. At first he worked for a house decorator, designing mouldings. Later he was employed by Carrière Belleuse, one of the successful sculptors of the day, who received many commissions for the decorative features of public buildings. For him he worked in Paris and after the War of 1870 in Brussels with the exception of two brief tours, one to Italy to see the works of Angelo, the other through Northern France to study the cathedrals.

His life now almost half spent, the statue into which he had wrought all that he had learned in those many years of search and study was on exhibition and Rodin awaited the result. The plaster cast modelled from a simple young soldier in Belgium represented a perfectly fashioned figure in the full vigor of grace and youth, one hand clenched to his head, the other holding an outstretched staff. "The Man Awakening to Nature" was its title at one time, as it seemed to Rodin to express the dawning sense of the beauty of the world almost dazzling the young wanderer through life. It was a symbol of Rodin's own awakening to the intimate beauty of the world about him.

To the critics who saw it at the Salon it evinced no such poetic suggestions. The statue commanded their attention and received it. But the verdict when it came was a staggering one. It was charged that the statue was a fraud, made from a mechanical mould obtained by the direct application of plaster to the figure of the model. A similar charge had been made in Brussels when the statue was shown there, but an indignant reply by Rodin at the time had apparently

laid low the rumor. Whether or not the Parisian charge was based on a knowledge of the Brussels criticism or was independently arrived at is not known, but the fact remains that Rodin found himself under a cloud of suspicion, which nothing he could do at the time sufficed to remove. Although he succeeded in securing an investigation of the charge by a jury, the non-committal report which they made in the matter did not help him. A year later, however, he was cleared through the petition of seven sculptors moved to intercede in his behalf, because quite by accident one of their number had the opportunity to observe Rodin at work in the studio of Belleuse and realized from the marvellous facility which Rodin displayed, that the charge of fraud was an injustice. Two years later, in the spirit of atonement, the State awarded Rodin a medal of the third class for the very statue which had been so libelled and for his "St. John, the Baptist," both of which were bought for the Luxembourg.

The forty years following this sensation (Rodin died in 1917) were marked by one long series of controversies, during which his art became the most violently hated and the most ardently admired in all Europe. His "St. John, the Baptist," represented in the act of walking, as if propelled by the message upon his lips, was denounced as a violation of a first principle in sculpture. Sculpture is in a sense architectural ornament and should, like the building itself, stand still, the critics admonished. And the public laughed at the thought of a statue which looked as though it might walk away. The "Genius of War" in 1880 violated another principle of sculpture, it was claimed.

It was exuberant and too violent in expression. Sculpture, the critics insisted, must always maintain a certain restraint, which Rodin in his eagerness for sensation had failed to observe.

His work was rejected in London, in 1886, by the Royal Academy, at which time Rodin was called the "Zola of Sculpture" in the English press. The charge in this case, repeated in Chicago in 1893, was a failure to observe the decencies which the best traditions of sculpture impose. At Chicago, where his works had been invited, his statue of "The Kiss" was put into a private room, where it could be seen only by special request. In the London episode Robert Louis Stevenson met the charge against Rodin by a spirited letter to the *Times*. In Sweden, as late as 1897, at the International Exhibition at Stockholm, there was another of the storms which Rodin's art precipitated, ending in the virtually unanimous declination by the Museum Commission of a gift which Rodin offered it.

But the bitterest episode in Rodin's career, the occasion of the most virulent criticism, resembling in a way the controversy over the Barnard Lincoln, was the "Affaire Balzac," as it has since been called. A statue of Balzac which he designed on a commission was received with such a chorus of angry disapproval that it almost broke his mighty spirit.

What was the secret of this opposition which Rodin's art evoked? At one time called a cheat because of his virtuoso cleverness in representing the form, he is later called an incompetent who hides his inability under a vague dressing gown. At another time called an iconoclastic breaker of traditions, he is then dubbed a

mere imitator of Angelo in the exaggeration of his modelling, or of the Greeks in his deliberately "dismembered bodies." Accused of realistic ugliness, of morbidity, of eroticism, of an unrestrained fancy, of deliberate sensationalism, he is later found guilty of a geometrician's interest in sheer abstraction, in meaningless patterns.

It has been one of the peculiarities of art in the last hundred years that with rarely an exception the outstanding figures have like Rodin been the objects of violent attack. A musical virtuoso reproducing the accepted masterpieces evokes a unanimous chorus of praise. A Rodin, a Monet, an Ibsen, a Whitman interpreting life in terms of their own fresh reactions to it are demons in Parnassus to one section of critics, artists and public, gods to another. For, towards the end, Rodin was an exalted hero. There were episodes like the ones in London, and in Prague when the horses of Rodin's carriage were unharnessed by the students and artists who drew him through the streets in triumph, the occasion when his "Thinker" was placed as a public monument upon the steps of the Pantheon, and the final victory of his career which came when the French Government stopped in its war deliberations long enough to discuss and take favorable action on the project of making Rodin's studio and the works in it a governmental museum.

If the art of Rodin is examined it will be found that he, like the other great stylistic interpreters of life in the last century, offended the rank and file of critics and public because he created what was virtually a new manner, new not as against the great traditions

19

of the past but new as compared with the pretty rhetoric, the cheap flubdub, the insincere pose, the rose-tinted lie, the myopic vision, which could see beauty only in a minutely painstaking and polished "finish," the hyperopic vision, which could see beauty only in a theme taken from the remote past or from the distant corners of the earth. Rodin, like the other modern masters, and like the great old masters, discovered beauty in the intimate, the immediate, the familiar and therefore the unobserved aspects of life. Though Rodin was neither a "modern" nor an "ultra-modern," he was hated from the start by the Academy which, in its attempt to institutionalize beauty, had created a body of rigid formulæ false both to art and life. Rodin did not observe these rules. But he was not consciously a revolutionist. Not even unconsciously has he been a breaker of traditions. Rodin is much closer to the Egyptians, the archaic Greeks, the Chinese, who felt the beauty of the form and fashioned it like craftsmen who love the stuff they work with, than were the academic idealists who fought him in the name of the "sacred traditions of the past."

Rodin's art was at one with all great art in its directness of inspiration. The nude is in a sense an anachronism, and it was almost inevitable that the feeling for the beauty of the body in its free movements should have been lost and forgotten, even amongst sculptors. For the Greeks, who saw the body nude or lightly draped, the figure was as expressive as the face of an emotional person. But to-day the academic sculptor models an attitude from selected figures, using the bust of one, the legs of another, the arms of a third,

the head of a fourth. Rodin, like the Greeks, saw beauty in the simple natural movements of the body. This made him seem a revolutionist, but the respect for the grace of the body's gesture consistent in all its lines is as old as all great sculpture. Few, however, were as willing as Rodin to let life surprise them with the variety of its movement and mood.

But though Rodin even in the "Man of the Age of Bronze" had already realized the importance of direct-ness of inspiration in catching the beauty of the figure in action, he later spoke of that work as cold; for he had become sensitive to certain aspects of nature and of his problem as craftsman, which he endeavored to solve through fresh moulding his material to his purpose. Style is a man's way of expressing the thing he feels. Rodin became sensitive to the ripple of light upon the surface of the figure, to the luminous glow which emanates from the nude, to the charm given to the form by the ambient air which bathes it. It is quite likely that his vision was quickened in this respect by the impressionist interest in atmosphere, and by the mist-enveloped portrait groups of his painter friend, Carrière.

Rodin could not express the luminosity which he felt in nature, the all-pervading light which playing upon surfaces transforms them without so modifying his earlier technique as to create his later style. He began deliberately to modulate the surfaces as he modelled them in such manner as to suggest the play of light without sacrificing what is proper to sculpture, the pleasure of mass and volume. In a sense, just as the correct local coloring of the earlier landscape painters

gave way to the modified hues as influenced by light so that trees were no longer brown of trunk and green of foliage, but ran a color gamut from gray to violet, so in Rodin the correct local modelling of the older schools gave way to atmospheric modelling. He sought not the structure as it would reveal itself to the eye of a dissecting anatomist, but the form as it would be seen in the reflection and refraction of light. It is this luminosity which is in large measure accountable for the appeal of heads like La Pensèe, his portrait heads of women, as well as many of his later figure compositions. Though Christian sculpture under the influence of painting and its own inherent ideals had softened edges to heighten by suggestion the expression of mystery through eyes lost in shadow, the problem of luminosity in marble and in bronze received its fullest study in Rodin's art.

Another phase of Rodin's stylistic development, related in part to the former, was his policy of deliberate exaggeration or "deformation," as he called it, in the interest of a more positive expressiveness in the action as well as in the light and dark of the figure. If while preserving the sensuous appeal of light-swept atmospherically-bathed forms, the emotional power of the marble is to be enhanced, he realized that suggestion rather than frigidity of statement is to be employed. Rodin conceived each statue in terms of a simple dominant expressive action in which all the parts swing together in response to a common impulse. Emphasis, exaggeration, a marked insistence on this central action in which details intensify interest, will best serve to stimulate the imagination and to convey

the mood of the action. Therefore, the dominant gesture of "The Balzac," to which every other consideration was so subordinated as to give the maximum force to the backward thrown head and figure; "The Tempest," in which with the most exquisite finish and variety of surface texture and silvery light, every detail intensifies the expression of gray wind-swept passion; "The Eve," in which every surface, seen from whatever angle, is controlled by the simple shrinking gesture of that body so soft and fleshy and warm, so sensitively troubled before the gaze of Adam.

To talk of Rodin's sympathetic vision, his sensitiveness to light, his perception of the unity of action in the body is all beside the mark if one fails to enjoy in Rodin the craftsman, who loved his material, and moulded it to his will. "Sculpture is the art of the hole and the lump," as Rodin bluntly puts it. Working with marble or with bronze he evokes from them a wealth of effects.

In textures his sculpture presents a varied surface of broad smooth planes catching luscious high lights, contrasting with soft roughly-grained areas trembling in half tone, these again giving way to recesses of softened shadow from which glints of subdued light glow. The material is not disguised, but its capacity for enchanting the eye is thoroughly exploited.

In recording movement his honest craftsman attitude led him to unceasing records of action caught on the wing. Those who have drawn from life know how far removed are the studio poses from the natural gestures of the body. These gestures, many as fleeting as a glance, Rodin fixed in swift sketches pinched in clay, or

in pen and wash drawings of which he made many thousands.

In the rendering of volume, the character and impressiveness of bulk, he learned quite early from a fellow-workman the principle which he applied with the most painstaking thoroughness throughout his life. Having conceived the dominant action, the actual transcription from life to art was to be undertaken from a succession of profiles. The true mass, as well as the ripple or wave movement of its surfaces, he studied from a great number of angles, not only from all sides but from above and from below. The completed surface, with all its play of texture and plane, conveyed as a result the effect of a mass organically related to its core. An apple modelled in this way would be more suggestive of the bulk of a mountainside than a mountain modelled in the more conventional way from just one of its profiles.

There are those who love the art of Rodin and who bring to his work a generously sympathetic response. There are those who are pleased by his work, but who give it only a passing consideration, so that they have enjoyed in a casual sort of way their occasional glimpse of a Rodin statue. There are those who find "The Kiss," "The Bronze Age" and other of his more smoothly finished creations agreeable, but who object to and quite positively dislike the rough-hewn ones. There are still many others who regard Rodin's work as absolutely repugnant, morbid, ugly and perverse. The lovers of Rodin need no intermediary; his violent opponents will brook none. But those who have given him only a passing consideration may welcome an at-

tempt to meet some of the typical difficulties which many experience in their first contact with Rodin.

It may seem presumptuous for the critic to attempt to answer for the sculptor. Are there not the works themselves? What more need be said? But from this point of view even a biographical statement is superfluous for the statues are complete in themselves, and either will awaken a response or not. In the mighty cycles of time some future age may dig up Rodin's work from beneath the ashes of the civilization of to-day and find itself without props of any kind, with nothing but the statues. These will then be accepted and admired or rejected and destroyed by virtue of their own inherent power over the surprised gaze of man. The critic who comes between the public and the work of art is performing a doubtful service, but since the fine art of seeing is so little cultivated there may be an excuse for a certain amount of explanation aimed at the stimulation of the habit of observation. Since so many permit art theories to stand between them and vision, it frequently becomes essential that criticism break down the preconceived notions of beauty which act like drawn shades between the world and genius. A few of the typical reactions of those of hasty vision or of preconceived art theories in the presence of the works of Rodin are these: "Why does Rodin exaggerate so? His heads of men look like caricatures." "Why does Rodin choose an ugly theme like 'The Old Courtesan'?" "Isn't there enough ugliness in the world without adding to it by the perpetuation of an ugly figure in bronze?" "Why doesn't Rodin finish his work instead of leaving off with a rough sketch, as in 'The Balzac'?" "Why does Rodin

ignore correct proportions in his figures, the arms of 'The Old Courtesan' seem a mile too long?"

The sophisticated reader may here lose patience. His attitude is that such people do not matter. But they do, for they form part of the general taste, and are a force for good or evil. The true artist may ignore them. He must ignore them. But the critic should remember that only as the great mass feels beauty more directly will genius achieve its fullest opportunity for fruition. It is the critic's duty to point out to the honest Philistines that they are standing in their own light creating obscurity through the shadows they themselves cast, and that they must give themselves the opportunity to form their judgments through that intimacy and communion without which there can be no true contact with either nature or art.

For it is well to remember that the eye has a dual function, and that discriminating vision is a development and not a common gift. The eye has been called the organ of anticipatory touch, and biologically it was no doubt developed to help lead man to his food and to his mate and to serve him generally in the struggle for existence. As Bergson puts it, "our perception is tied to our action." Even in the more complex modern life, most people still use their eyes only in so far as seeing is essential to self-preservation and well being. Quite undeveloped is the secondary function of the eye as a window through which man looks out upon the kaleidoscopic phenomena of nature.

The true artist is he who possesses this quality of sympathetic vision, seeing the world in its endlessly varied pattern and in the inexhaustible variety of its

inflections and moods. But it is not enough that the artist be sensitive to the beauty of the world about him, he must also be the master of his material, skilled in controlling his marble, pigment, action or the spoken word to convey something of the glamour which he finds in the world. To test the vision of the artist by the general lack of vision is to assume that disinterested seeing is common. To denounce the artist's style or manner of using his material if this seems strange and contrary to habit, without first endeavoring to see whether some new sensitiveness did not make that style necessary, is to miss the point of art expression. For the vision of most people is primarily practical; the vision of the artist is sympathetic.

If this is true, it becomes evident that what seems exaggeration in Rodin may represent his clearer and intenser seeing. The note of caricature which some feel in Rodin's heads of men may be accounted for by the fact that they are so accustomed to the conventional falseness of professional portraiture with its hollow, superficial masks, that a head seen boldly is like a shock. Let anyone look at the man opposite in the subway or even at his own father, looking at the head squarely, and he will see whether life is not much more like the tempestuous "caricatures" of Rodin's sculpture than like the usual retouched portrait, wrinkles removed while you wait. Those who believe that they have seen the head may find it an interesting experience before they look at a Rodin again to let their eyes wander as a sculptor's would over its surfaces. Any head will do. In bulk it is elongated like a pear; narrow, sharp edged like an axe blade, or cubic like a granite block.

AUGUSTE RODIN

The forehead a broad arch, fitful and agitated of surface, deeply cleft above the eyes, is sharply cut at the sides to recede towards the temples. The nose is large, projecting, the hard bone of the bridge contrasting with the sensitively vibrating tunnelled nostrils. The adventurous journey can be continued through the recessed valleys undulating of surface in which dwell the eyes. Still to be surveyed are the involved labyrinth of the ear, the mouth, rival of the eyes in expression and the sharp turn at the chin and jaw. Then back of the maze of the ear the sharp planes simpler and larger of sweep, above which the massed hair waves in tangled tumult. No one who has once truly looked at the head of a man will ever again call the portraits by Rodin caricatures, even if the sculptor in his interest in light and dark has intensified "the hole and the lump."

The "Old Courtesan," who, stirred by memories of the past, contemplates her present state, a withered rose mourning its own decay, is, in the opinion of many, an example of ugliness morbidly selected for portrayal. The artist, in the conception of the people who object so strenuously to "the ugly," is like a guest at the table of life, who must earn his meal by saying pretty things to his hostess, the public. He is the entertainer who will help digestion wait on appetite, even if need be the panderer who will give an edge to desire. He must remember his role. Seriousness is taboo. But just as Dante forgot his assigned part in the "Divine Comedy," just as Ibsen forgot in "Ghosts," so Rodin forgot in the "Old Courtesan." The perversity in these cases is not the artist's who accepts death, old age and

brooding melancholy as facts. Perverse is the mental attitude of those who insist on wearing blinders and rose-tinted glasses. Like Dante and like Ibsen, Rodin saw the withering of the body as only a phase in the eternal pulse of life and death. And how that pulsation moves him to awe and wonder.

The stamp of the age is upon his art. The theology of the Middle Ages was certain of the future. The aristocratic renaissance dallied with memories of the past. The nineteenth century renounced the golden age of the court poets and the heaven of the monks to grasp more passionately at the present, at the richest fulfil- ment of life here and now. But in "The Age of Bronze," in the "Adam," in the "Thinker," in the "Gate of Hell," Rodin reveals himself perplexed by the mys- tery of the life which he so reverences. His figures are strangely stirred by the currents of energy which pass through them, by the fascinating intimacy and cool aloofness of the world about them, by the subtlety and intensity of their inner moods.

The clenched hand pressed to the head in the lightly poised "Age of Bronze," thrilling with some keenly felt mysterious awakening; the uncomprehending head of "Adam" slowly raising itself to a position of dom- inance above the perfect engine of his body fresh wrought of earth and inspiration, the introspective mood of the "Old Courtesan" meditating on youth and the brevity of charm, the brooding "Thinker," whose massive body is all tense with the concentration of his perplexity as he sits above the "Gate of Hell," where the agonized forms of men and women writhe in the torment of the fevered struggle called life, these are

all symbols of that wonder concerning life which Rodin combines with his love of its forms.

The "Old Courtesan" symbolizes the most terrifying phase of life, the decay of vitality, the withering of the body, the darkening of the mind, the premonitions of death. The vivid realization of the certainty of death leave life differently colored. Each of us making our little bargains with life must some day feel the symbolism and the sympathetic realism of that statue. There are few great works of art inspired by the themes of death. "The Old Courtesan" may be ranked with these. Far more sombre than the mediæval "Dance of Death," with death the reaper gathering in his harvesting, the bride at her wedding, the sculptor at his chisel, the mother nursing her babe, is this figure in which Death is singing sad memories of youth into the ears of old age.

Now what can be said to those who, looking at so profoundly stirring a work, discover that the arms are overlong? It is not their fault if the theory of the artist as an anatomist who draws and models "correctly" has displaced the conception of the artist as one who uses the material he loves to express his feeling about life. Rodin finds the same weird beauty in the gesture and detailed modelling of the gaunt old body as a great landscape painter like Ryder might have found in a storm-swept, devastated scene. Mere photographic imitation, line for line, would not suffice to reproduce the mood any more than a phonographic reproduction of the actual conversations in a given tragedy in life would convey the conflict which is the essence of the art of the drama. A touch of exag-

geration, and of emphasis in the parallelism of the tense, gaunt, long lines is essential to the mood and its carrying power. This deliberate exaggeration of the elements of expression is found in all the arts from the folk song of old to a drama by Shakespeare or a symphony of Beethoven. Yet academic criticism in the case of painting and sculpture has succeeded in obscuring this fact in the effort to justify the pretty, smooth, polished "finish" of the "correctly" modelled figure.

Great artists of all times have frequently strained at the leash of form, in their eagerness to obtain a fuller expressiveness. The orchestra seemed too small for the symphonies in the ear of Beethoven, marble too cold for the vision of Angelo, words too definite for the moods of Poe. Rodin, like Angelo, sometimes saw in the rough-hewn block as he worked over it that power of suggestion and completeness of design which further work would only dwarf and limit. He accepted the hints which the material gave him. Just as in "The Hand of God" so delicately sensitive, so magically skilful, so intelligently powerful the figures of Man and Woman curled like two petals barely disengage themselves from the rough earth of which they are moulded, so in many of the statues by Rodin his own creations barely emerge from the stone which envelops them.

Expressiveness and not finish is his ideal. In "The Kiss," executed shortly before the "Balzac," he proved himself master of the most highly polished delicacy of surface, all a-tremble with the quiver of tender love. But the "Balzac," when it emerged in the rough as a huge monolith, a mighty, towering block, seemed

to him complete in its mood as well as in its structure, and so was left free from the elaboration of separately wrought folds, hands and similar inconsequentials. Every detail which he might have added would have reduced the force of that "Balzac" just so much. That his lack of finish was not due to sheer laziness should be proved to those who require proof by the fact that Rodin made preliminary studies in the nude before proceeding to model the draped figure.

Yet when the statue was exhibited at the Salon the sensational outburst of abuse which it aroused was probably the most trying ordeal which any sculptor in the last century was called upon to face. Its rugged simplicity struck the critics and the crowd as such a stupid jest, that café singers sang scurrilous songs about him in the cabarets, street comedians aimed their vile shafts at him, and statuettes of Rodin himself modelled as a snowman, in imitation of his statue, were sold like Billikens in the shops. It would seem that offending against the idol of finish and detail is an artist's worst crime in the eyes of the uncritical. It is quite likely if these had been called on the seventh day to criticize the Creation they would have denied its beauty for the lack of polish on a mountainside.

Another of Rodin's statues which has provoked much difference of opinion is "The Thinker," which is frequently complained of as too muscular and huge to represent a man of thought. But Rodin was not fashioning a modern "intellectual," bespectacled and anæmic. Comparison with Angelo's "Il Penseroso" reveals how much more thoughful and concentrated of effort is this massive brooder. The baffled intensity of his desire

to grasp the key to the mystery of life is expressed not only in the head with its troubled eye and mouth beneath the overhanging clouded brow, in the supporting hand upon which the chin rests firmly the set jaw clenched against it, the great shoulders and trunk straining forward towards the truth, but even in the very toes which grip the earth and convey the power to pivot the whole body into action towards an end, when once that end has been grasped.

The Middle Ages had also symbolized the perplexity of man in the presence of the spiritual problems of life through a gigantic figure in the legend of Christopher. This giant, so large of mould that a tree trunk served him as a staff, went through the world seeking a fearless king, whom he would serve. When the Oriental monarch, whom he thought a dauntless master, trembled at the mention of the devil. Christopher transferred his allegiance and went in search of him whom the king had feared. He soon found the devil at the head of a tremendous army of followers and served him until he observed that every time they passed a crucifix along the roadside the devil grew pale. Saint Christopher now set out in search of Christ, whom the devil feared. Two monks of whom he inquired his way told him that only through prayer could Christ be found. But the giant in his great strength did not know what prayer meant. At their suggestion, however, he used his strength to serve through action by helping distressed wanderers across a dangerous mountain stream. One night in the storm he found a crying child near the river's edge whom he placed upon his shoulder to carry it across to shelter. But as he reached midstream the

giant found his whole body giving beneath the weight of the child. As his muscles grew more and more tense he thought to himself, "It is strange that I, who have carried great loads without effort, should be weighed down by so light a burden." Then, as though the child had read his mind, it answered his query, "Be not surprised that you are bent down by my weight, for in carrying me you are carrying the weight of the world." Rodin's "Thinker" is another Christopher, a physical giant, whose whole strength avails him not as he bends beneath the weight of the world. In the presence of the mystery of life and death the strongest and the weakest are one.

Though the thinker doubts, the lovers in the fresh ardor of youth grasp at the fleeting moments which seem to give purpose to life. Their adoration, their embrace, their hunger for life, he has modelled again and again both in the free abandon of the pagan in satyrs madly kissing, laughing, struggling nymphs, and in the more self-conscious absorption of modern love, tender, reverent and finely sensuous. The theme of the love of man and woman fascinated him quite possibly because it is a source of so many naturally complete groupings of two figures. To compose two figures into a unit, the gestures mutually completing one another, requires the themes of combat, of mother love, of the love of the man and woman. The Greeks in their wrestlers, Angelo in his "Madonna and the Dead Christ," had wrought powerful groups from the former themes. Rodin in his Brother and Sister created a group of the quieter and gentler affection. But in a long series of works, many of which have never been

publicly exhibited, Rodin glorified the themes of love.

It was only to be expected that he should on that account be labelled erotic, and even obscene by some, an English critic having gone so far as to say that the French stomach toughened by Zola might put up with Rodin, but it could hardly be expected that the English would tolerate him. It was this charge which Stevenson replied to in a spirited letter, in which he pointed out that Rodin was absolutely free from any false pandering tricks, that his statues were simple expressions of the beauty of love.

There are those who would expurgate the body if not from life, at least from art, as belonging to that side of man's nature which is lesser and unworthy. This mystic devotion to higher things is quite frequently the hallmark of the impotent, eager to place restraints upon youth and its wholesome vitality. Rodin, like Whitman in his "Leaves of Grass," opens the gateway of art to the theme of love treated as frankly and as reverentially as are the themes of toil, of rebellion, of war and death. In so doing he has enriched the content of sculpture by some of its most beautiful groups.

By comparison with the range of expression and gesture in Rodin's works almost every other sculptor seems like a musician playing one tune. Even the mighty Angelo did not manifest the range of action and mood present in Rodin. In "The Burghers of Calais," those six citizens of the old city self-elected to surrender themselves to death so that their city may be saved, Rodin had been commissioned to do a single figure, but the theme as recorded in the old chronicles

so moved him that he determined to render it dramatically in a complete group. He had rendered love, in which two forms are bound by a single impulse, subtly varied and yet blending; but here was a theme in which six figures become a unit, through the binding power of group feeling, of civic pride and love of their fellowmen. Those burghers of old he portrayed in a work quite simply human, free from the heroics of the center stage, eloquent instead of the fine gesture which comes from the nobility of the mind. As they walk slowly through the streets to surrender themselves to death the character of each and his attitude towards the event and towards the end expresses itself in the carriage of the whole body. Richly contrasting as their moods and movements are, they are nonetheless actors in a common drama, sustained by and sustaining one another. The lines and forms of the group interrelate with the effect of a beautiful dirge, and one almost hears the triumphal strains of a funeral march mingled with the weeping of children as these men silently pass onward.

That group which Rodin wished to have erected in the heart of Calais was placed near the sea, to be dwarfed by its ample horizons. But who can persuade the minds of men to-day that the designer and the sculptor know principles of light and dark, of scale and setting, as immutable as the laws of nature, and that their knowledge should be respected in planning the surface aspects of life?

In a world of large cities, cumbered with outrageously rhetorical statues. devoid of enchantment of surface, beauty of action, or nobility of form, the works

of Rodin are crowded into the narrow hallways of museums, or placed without regard for setting in the homes of the wealthy. Very rare were the occasions when his statues were direct commissions for public monuments. Even in Paris there are only three of his statues in the open. Rodin has passed away, but it is not too late to give to his larger works the place that they were meant to have, to enable them to mingle their lives with ours in the busy squares of the city, to mingle their reveries and doubts, their passions and their hopes with ours, in the play of sunlight and of shadow in our public parks.

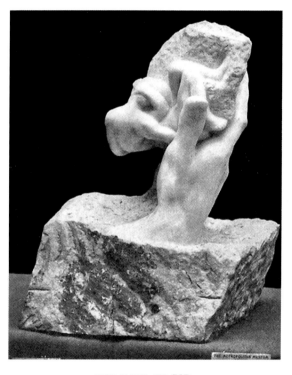

THE HAND OF GOD

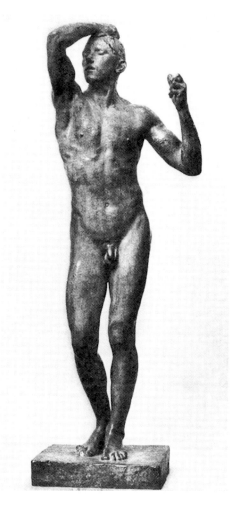

THE BRONZE AGE

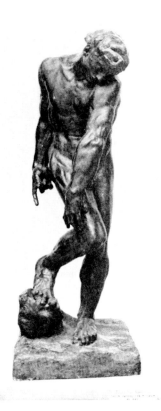

ADAM

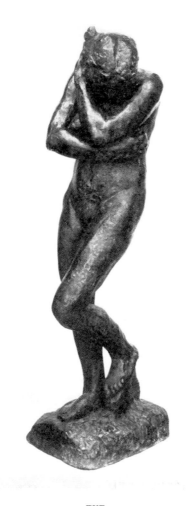

EVE

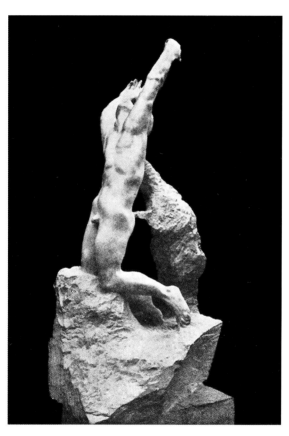

THE PRODIGAL SON

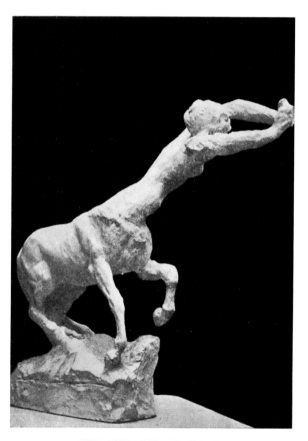

THE SOUL AND THE BODY

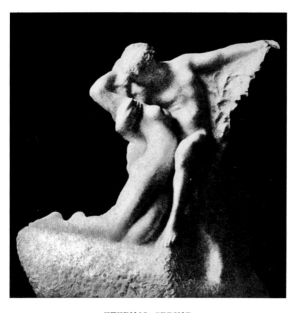

ETERNAL SPRING

THE DANAÏDE

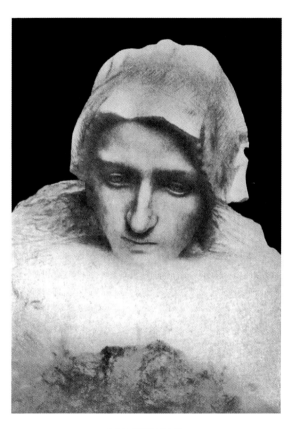

" LA PENSÉE "

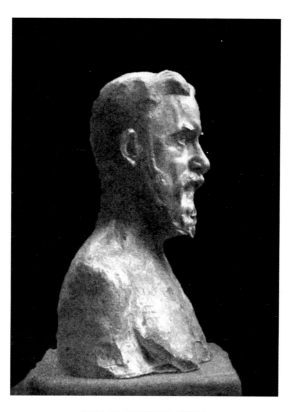

GEORGE BERNARD SHAW

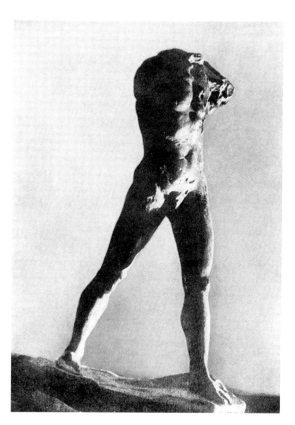

NUDE STUDY

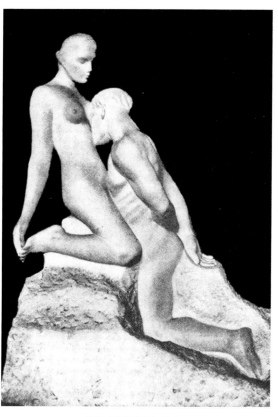

THE ETERNAL IDOL

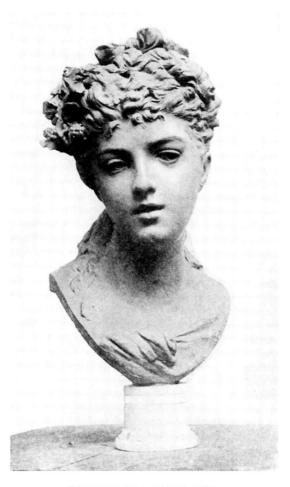

PORTRAIT OF A YOUNG GIRL

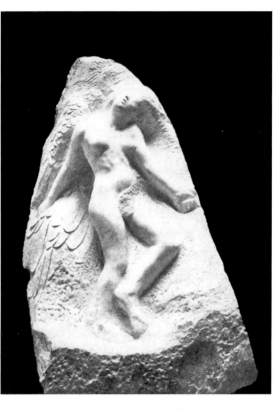

THE BROKEN LILY

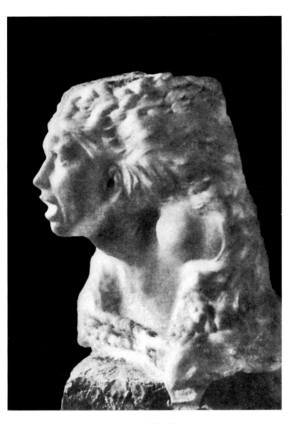

THE TEMPEST

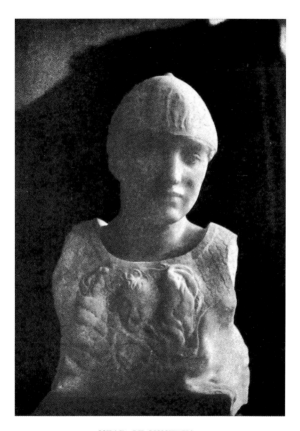

HEAD OF MINERVA

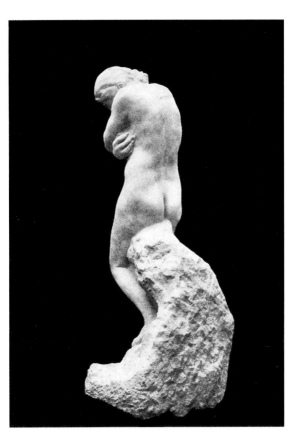

EVE

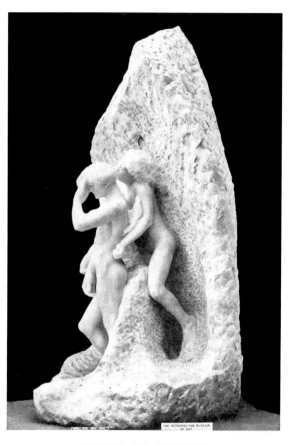

ORPHEUS AND EURIDYCE

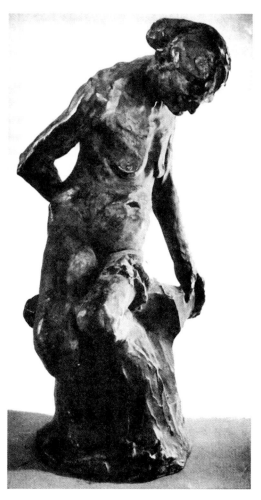

THE OLD COURTESAN

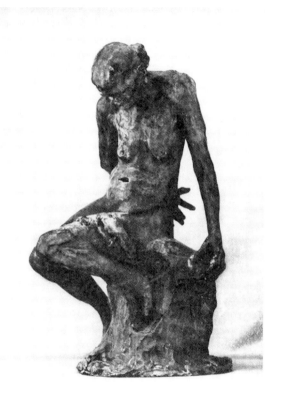

THE OLD COURTESAN

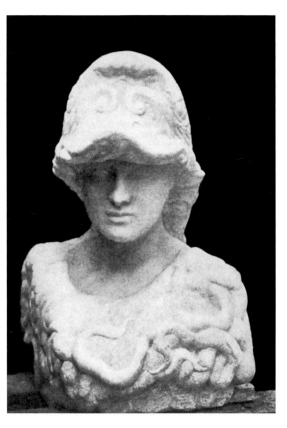

MINERVA

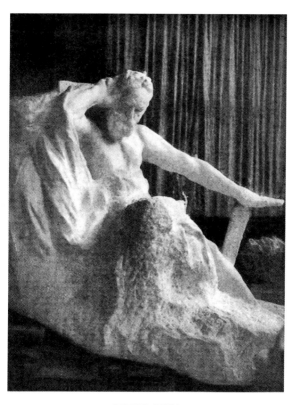

VICTOR HUGO

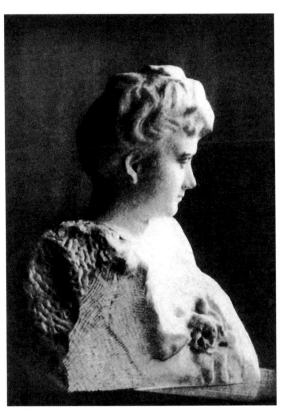

PORTRAIT OF MRS. X.

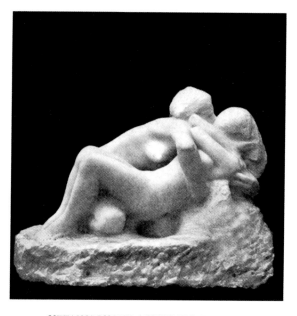

METAMORPHOSIS ACCORDING TO OVID

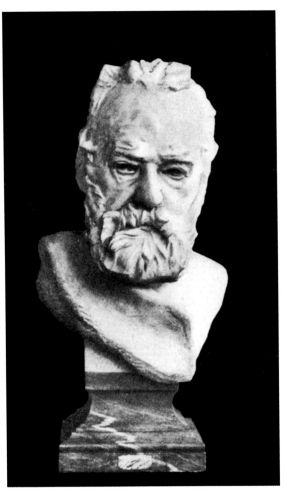

BUST OF VICTOR HUGO

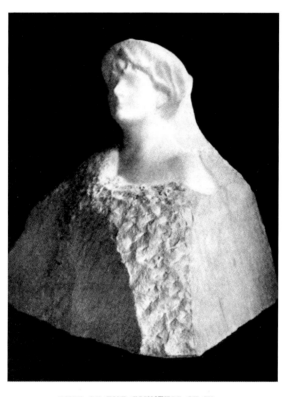

BUST OF THE COUNTESS OF W—

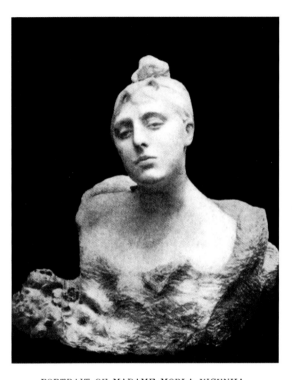

PORTRAIT OF MADAME MORLA VICUNHA

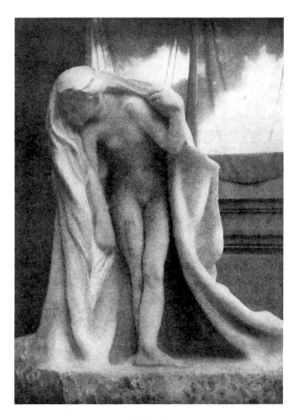

PSYCHE

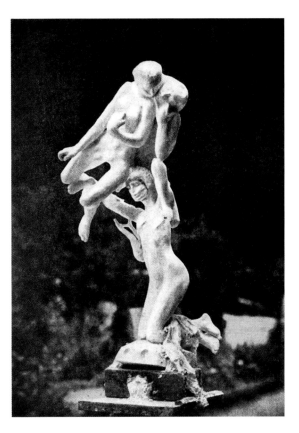

THE POET AND THE MUSES

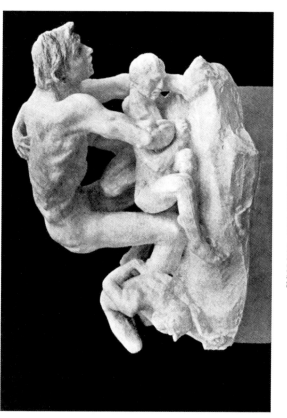

UGOLINO AND HIS CHILDREN

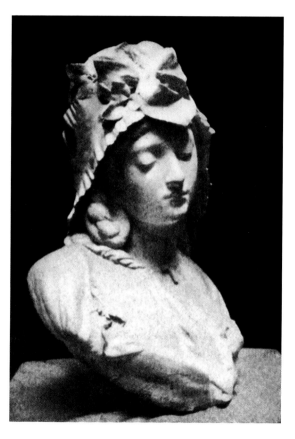

THE VILLAGE FIANCÉE

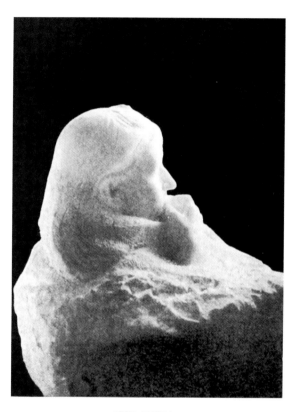

THE ADIEU

THE BATH

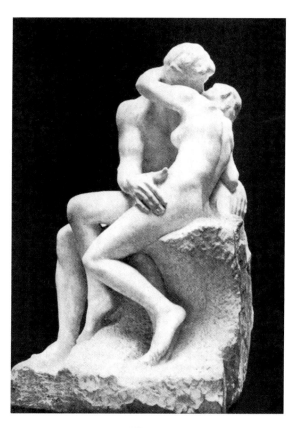

THE KISS

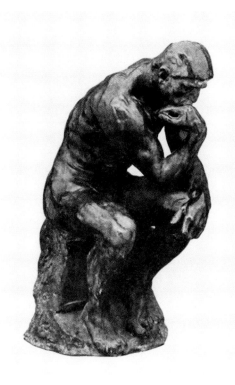

THE THINKER

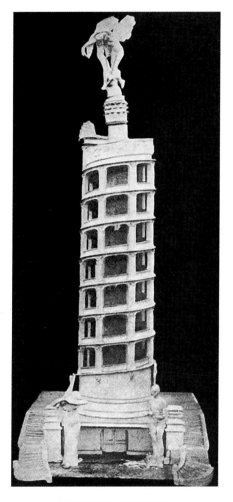

THE TOWER OF LABOR

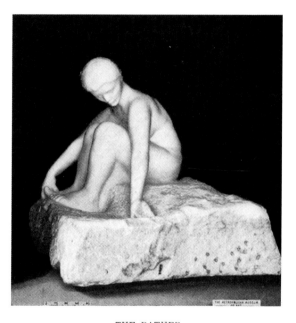

THE BATHER

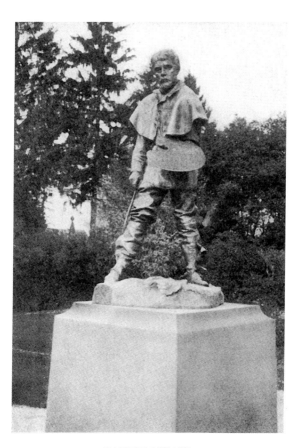

BASTIEN-LEPAGE

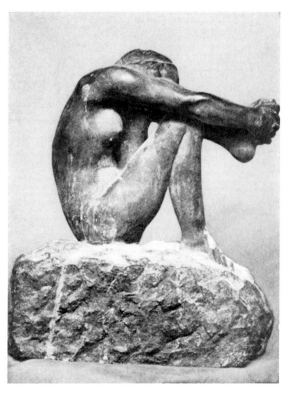

DOUBT

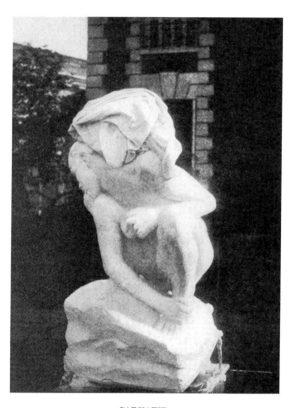

CARYATID

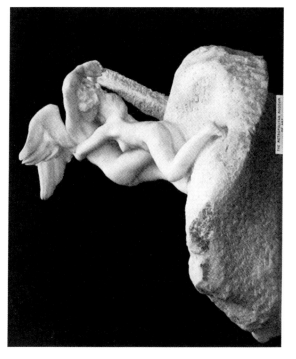

THE METROPOLITAN MUSEUM
OF ART

EROS AND PSYCHE

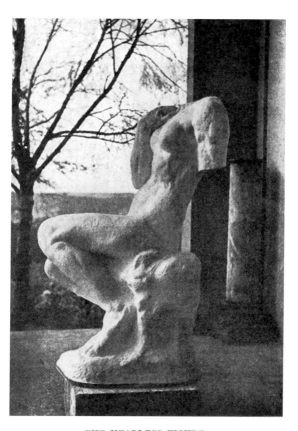

THE HEADLESS FIGURE

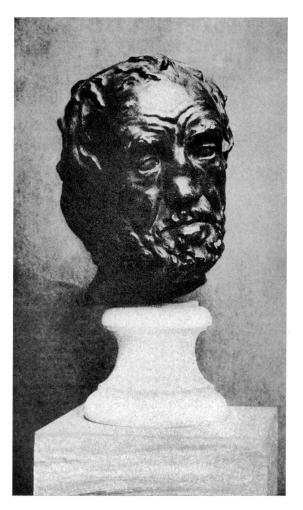

THE MAN WITH THE BROKEN NOSE

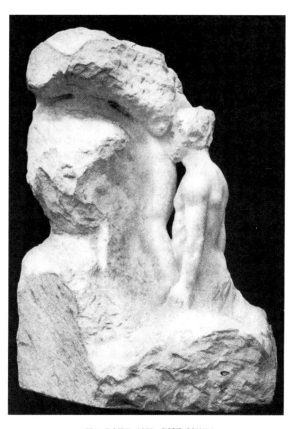

THE POET AND THE MUSE

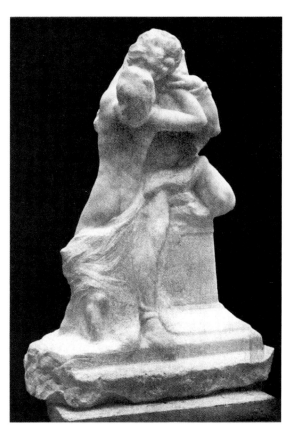

ROMEO AND JULIET

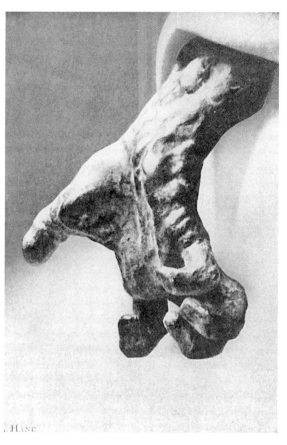

STUDY OF A HAND

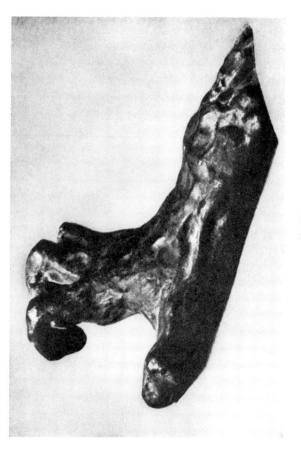

HAND

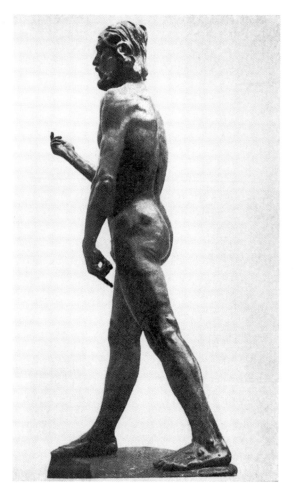

ST. JOHN THE BAPTIST

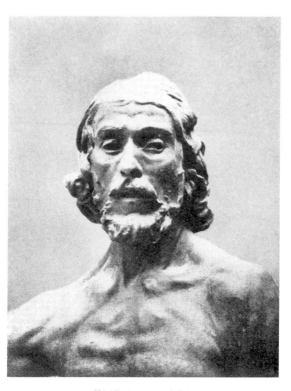

HEAD OF ST. JOHN

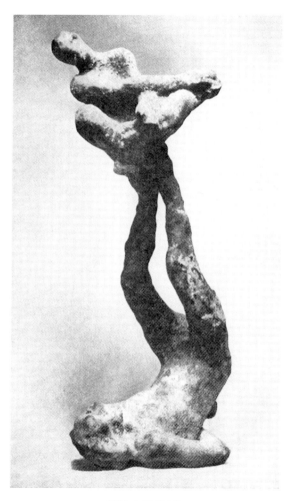

THE ACROBAT

FUGIT AMOR

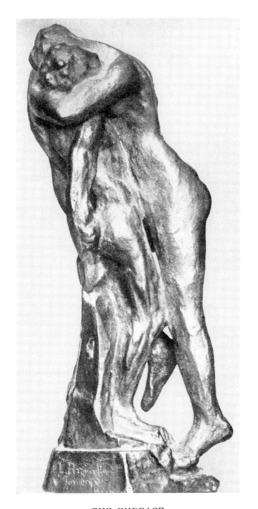

THE EMBRACE

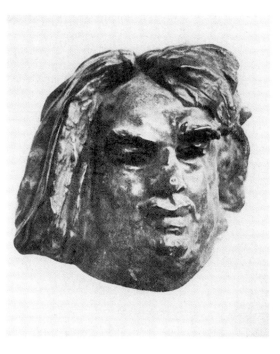

STUDY FOR HEAD OF BALZAC

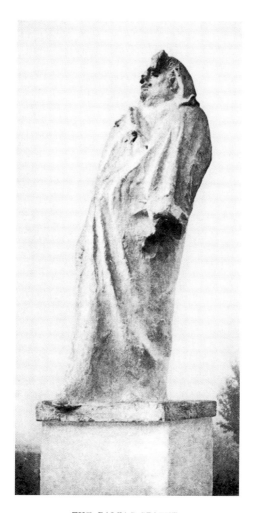

THE BALZAC STATUE

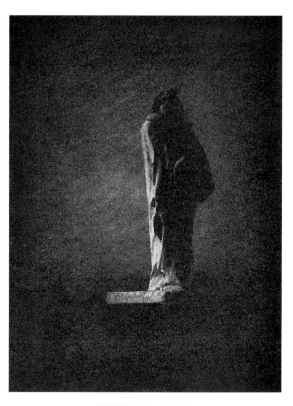

STATUE OF BALZAC
Photograph by Steichen

THE BURGHERS OF CALAIS

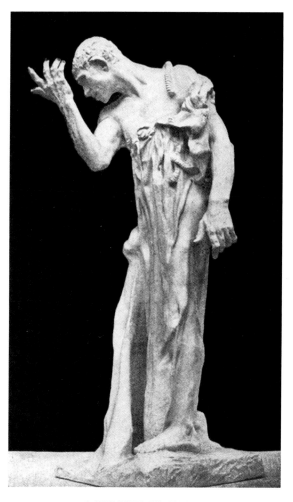

A BURGHER OF CALAIS

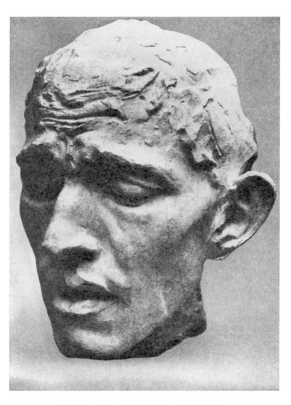

HEAD OF A BURGHER OF CALAIS

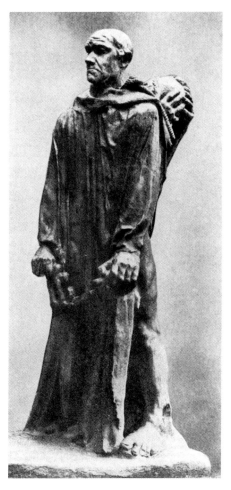

EUSTACHE DE ST. PIERRE
(From The Burghers of Calais)

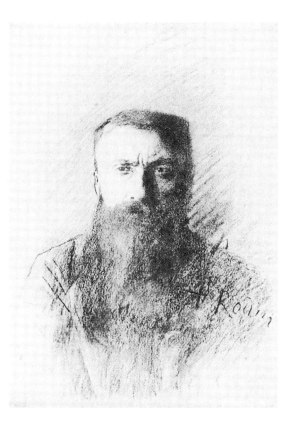

PORTRAIT OF RODIN
Drawn by Himself

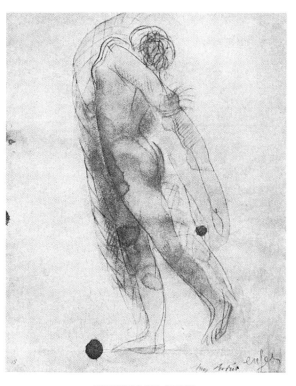

DRAWING BY RODIN

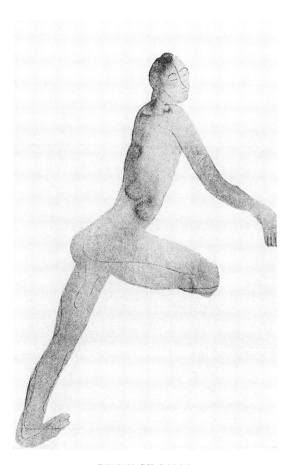

DESIGN BY RODIN

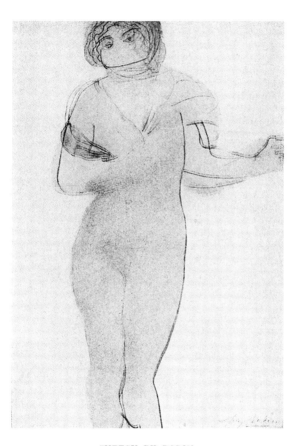

SKETCH BY RODIN

WASH-DRAWING BY RODIN

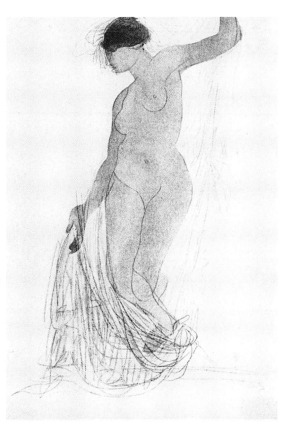

WASH-DRAWING BY RODIN

First published in the United States in 1918 by Boni & Liveright, Inc.

This facsimile edition first published
in the United Kingdom in 2018 by Art Books Publishing Ltd

Copyright © 2018 Art Books Publishing Ltd

All rights reserved. No part of this publication may be reproduced
or transmitted in any form or by any means, electronic or mechanical,
including photocopy, recording or any other information storage and
retrieval system, without prior permission in writing from the publisher.

Art Books Publishing Ltd
18 Shacklewell Lane
London E8 2EZ
Tel: +44 (0)20 8533 5835
info@artbookspublishing.co.uk
www.artbookspublishing.co.uk

British Library Cataloguing-in-Publication Data
A catalogue record for this book is available from the British Library

ISBN 978-1-908970-38-1

Designed by Art / Books
Printed and bound in Latvia by Livonia

Distributed outside North America by
Thames & Hudson
181a High Holborn
London WC1V 7QX
United Kingdom
Tel: +44 (0)20 7845 5000
Fax: +44 (0)20 7845 5055
sales@thameshudson.co.uk

Available in North America through
ARTBOOK | D.A.P.
75 Broad Street, Suite 630
New York, N.Y. 10004
www.artbook.com